O9-BTZ-132

JOHN SINGER SARGENT

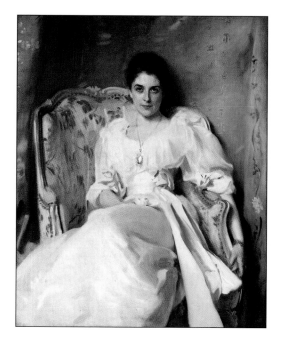

T&J

Published by TAJ Books International LLC 2013
219 Great Lake Drive
Cary, North Carolina, USA
27519

www.tajbooks.com
www.tajminibooks.com

All notations of errors or omissions (author inquiries, permissions)
concerning the content of this book should be addressed to
info@tajbooks.com.

ISBN 978-1-84406-238-6

Printed in China.
1 2 3 4 5 17 16 15 14 13

JOHN SINGER SARGENT

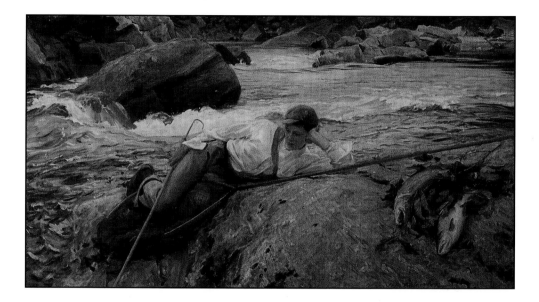

T&J

BY SANDRA FORTY

JOHN SINGER SARGENT

1856–1925

Painter of languid, elegant, Edwardian beauties and sharply dressed gentlemen, John Singer Sargent was the ultimate society painter. He knew everyone who was anyone and was on personal terms with many of them, including Edward VII and the U.S. presidents Roosevelt and Wilson. This social standing was justified. Sargent was one of the greatest portrait painters ever, able to convey the personality and style of his sitters—comparable to the great Velázquez himself, of whom he was a great admirer.

Although Sargent was painting throughout the late-19th and early-20th centuries—a time of great turmoil in art—little hint of this is reflected on his canvases. At most, Sargent gives only a shimmer of light to the clothes of his sitters and to their backgrounds. For such a conservative approach, he was roundly criticized by some detractors, and indeed, after his death, his work went out of fashion and largely disappeared from the public consciousness. A reappraisal of his skill and an unbiased view of his exceptional ability began to gain momentum in the 1960s. Since then, estimation of his work has risen with each passing year.

One reason for Sargent's fall from grace was that at the peak of his fame he turned his back on portraiture. He became thoroughly bored with the tedium of the genre and the people he had to deal with, even though they were some of the most important, influential, aristocratic, and beautiful movers and shakers of the Edwardian era. Instead, he concentrated his talents on making landscapes, architectural studies, and pictures of friends and family. He loved using watercolors both for their quickness and convenience, and also for the way they could convey the light. A large part of his later years were spent researching and painting large artworks for institutions such as the Boston Public Library.

Sargent was born in Florence, Italy, in early January 1856 while his parents were on an extended European tour that turned into a lifetime of travel. Two years earlier, his parents had lost their two-year-old daughter, Mary, and her grieving mother, in particular, needed a change of scene to recover her mental and physical health. Sargent's father, Dr. Fitzwilliam Sargent, Attending Surgeon at Wills Hospital in Philadelphia, took a sabbatical from his career, and with his wife, Mary Newbold Singer, who had received a substantial inheritance from her father, decided to travel to Europe to dispel their grief.

Initially, the couple went to Geneva, but soon started touring as the fancy took them, renting a new apartment, hiring temporary servants, sightseeing, and enjoying life before moving on again

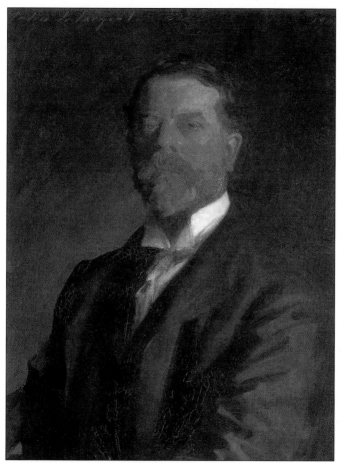

Self-portrait, 1906

after a month or two. Fitzwilliam had intended to continue his medical career by further study in Europe, but their lifestyle prevailed against this and he eventually resigned his post in 1857.

After John was born, he was followed quickly by sister Emily later the same year. It would be 10 years before another sister, Violet, was born in 1870. In the intervening years, two other siblings—Mary (1861–65) and Fitzwilliam (1867–69)—died in infancy, leaving their mother repeatedly devastated. She found traveling the only comfort, continually moving from place to place. In spite of their age differences, the three surviving siblings remained close all of their lives.

Their itinerant lifestyle meant that none of the children received much of a formal education. John was encouraged to learn by his father, who brought him interesting books to read. He was taught to play the piano and remained a skilled musician throughout his life. Much of John's education was gathered in the museums and galleries of Europe as the family moved around. His proficiency with various European languages came from his many nannies.

One thing was obvious from an early age—John Singer Sargent had an exceptional ability for art. His one continuous interest, promoted actively by his mother, was drawing, and from the age of 12, he sketched the places the family visited. This pursuit left a huge legacy of sketchbooks filled with landscapes, figure studies, and copies of paintings and sculptures from across Europe.

His parents' ambitions for him differed greatly. His father had wanted to join the U.S. Navy and desired the same for his son. His mother, however, wanted him to be an artist and successfully launched him in that direction. Despite her husband's reluctance, she found professional teaching for her son when he was 14 years old.

The beautiful city of Florence was one of Sargent's parents' favorite places, and the family generally spent the winter there. It was there in the fall of 1873 that Sargent was enrolled at the Accademia della Belle Arti. Many other English-speaking students, many of them fellow Americans, attended the school. In particular, Sargent became friends with the American-German painter Carl Welsch.

Sargent learned to make accurate drawings of antique sculptures that he saw in Florence, but soon wanted a greater challenge. Sargent's sights shifted to Paris, but by the time he arrived all the ateliers were full. Finally, he stumbled upon the atelier of portraitist Carolus-Duran (properly, Charles-Emile-Auguste Durand) who agreed to accept Sargent as a student and to prepare him for the tough examinations to get into the École des Beaux-Arts. For the first time, Sargent, at the age of 18, lived alone.

Carolus-Duran was a noted academic painter who produced portraits of fluid brushwork constructed from tonal blocks worked directly onto the canvas without the use of preparatory sketches and studies. Sargent was duly impressed and

incorporated many of Carolus-Duran's ideas into his work. Starting in May 1874, Sargent prepared for the biannual examination—the concours des places—that would determine his acceptance into the prestigious École des Beaux-Arts. Helpfully, in September, his family took an apartment in Paris at 52, rue Abbatrice.

Between September 26 and October 16, Sargent was examined in life drawing, ornament drawing, anatomy, and perspective. Remarkably, for a foreigner and a first-time test taker, he passed, being ranked 37th of 162 applicants and the only one of Carolus-Duran's pupils to pass that fall. (The exams had to be retaken and passed twice a year, every year, which he did until he left).

During the day, Sargent continued to study with Carolus-Duran, and then as a Beaux-Arts student, continued with two more hours of study in the evening at Monsieur Adolphe Yvon's life classes, followed by two more hours at the popular artist Léon Bonnat's studio.

During this period Sargent met other aspiring artists, many of them American. He also met and befriended a young law student, Robert Louis Stevenson, whom he later painted three times. His restless parents were still continually traveling, staying in one place for a short time before moving on, and Sargent joined them during his school vacations, making watercolor sketches *en plein-air* of the scenes he saw around him. While passing the summer with his family in Saint-Enogot, Brittany, he made a collection of sketches he would later use

for his first celebrated painting.

Sargent had never visited his putative homeland. But just before his 21st birthday, he had to visit the country in order to retain and claim his U.S. citizenship. Accordingly, in May 1876, he accompanied his mother and his sister Emily to Philadelphia. Still working at his art, he made a portrait of Miss Fanny Watts, a family friend, which became his first accepted painting in the 1877 Paris Salon. By October, Sargent was back in Paris studying. In March 1877, he took the concours again and passed in an unprecedented (for an American) second place to continue studying. At the same time, alongside his mentor Carolus-Duran and his friend James Carol Beckwith, he was working on ceiling murals entitled *The Triumph of Maria de Medici* for the Palais du Luxembourg in Paris.

In summer 1877, Sargent returned to Brittany looking for inspiration for his second submission to the Salon. *Oyster Gatherers of Cancale* took him many sketches in the field and hours of labor in his Parisian studio at 73, Nôtre Dame de Champs, which was shared with his friend Beckwith. The final result, of which he was very proud, was exhibited at the 1878 Paris Salon in May where it received an honorable mention—the first public award Sargent received. He was 22 years old.

Along with Beckwith and other American artists, Sargent became a founding member of the Society of American Artists in New York. As the Impressionists had in Europe, they set themselves up against the art establishment to showcase their

contemporary art.

Now that Sargent was a known name in England—thanks to exhibiting at the Salon—he started to get commissions for portraits. In 1879, he received five commissions. He found that the more portraits he painted, the greater the demand for his work. As often as he could, he still joined his peripatetic family for extended holidays around Europe, but always returned alone to Paris to continue painting. This pattern of study and travel continued throughout his artistic education.

In 1879, Sargent went to Spain in the company of two artist friends, Charles-Edmund Daux and Eugene Bach, to see the paintings of Velázquez in the Prado. He spent much time copying them and admiring the Spaniard's technical refinements and subtleties. That same year he produced a portrait of his mentor, Carolus-Duran, which was shown at the Paris Salon where it was given an honorable mention. The following year, in January, he went to Tunis and Tangier for a month to paint the white buildings found throughout the region. Later, in 1880, he journeyed to the Netherlands and Belgium where he admired and copied the works of Frans Hals. In 1881, he was in Venice, studying with a studio at the Palazzo Rezzonico and absorbing all the culture he could and (possibly) meeting fellow expatriate James McNeill Whistler.

All the time he traveled, he painted travel scenes, but he earned his money as a portraitist with full-length portraits of the wealthy wives and daughters of top Parisian society, ladies such as Mme. Ramón

Subercaseaux, Mme. Edouard Pailleron, and Mrs. Henry White, the wife of an American diplomat. First, he would make a number of sketches and watercolor studies, and then proceed to paint the portrait on canvas.

In 1883, Sargent started working on a portrait for his next Salon submission: a portrait of Mme. Pierre Gautreau, the celebrated New Orleans-born society beauty. He had first seen her in 1881, when she was the most celebrated beauty in Parisian high circles. He longed to be introduced to her so he could offer to paint her portrait. She eventually consented to be painted at home in Brittany at Les Chêes Parramee, but proved to be a difficult sitter. Sargent complained to friends of her "laziness."

For his seventh successive showing at the 1884 Paris Salon, Sargent was rightly nervous about his latest submission. The virtually life-sized portrait of Gautreau, entitled *Portrait de Mme XXX* (later shortened to simply Madame X), was accepted by the committee and hung in the Salon. The public was horrified, and her identity immediately exposed. Sargent had already painted two far-more controversial portraits of the Spanish model Carmela Bertagna and Rosina Ferrara of Capri, but those portraits had not been put on public display, and thus went unnoticed by the conventional and conservative Salon crowd.

Hard as it is to believe today, the portrait *Madame X* was considered scandalous for being far too explicitly sensual, and Sargent found himself at the center of an artistic storm. Her pale skin and

apparently suggestive pose shocked straight-laced Parisians. *Madame X* portrays haughty, refined elegance. Mme. Gautreau is depicted as beautiful and clearly rich. The glint of her wedding ring on her left hand did nothing to assuage the scandal. Originally, the right strap of her gown was shown slipping off her shoulder—Sargent repainted it in place to placate the critical storm, but it was a wasted effort. Her mother demanded that the painting be withdrawn and clearly intended to destroy it. Sargent refused.

The ruckus continued after the exhibition. Sick of continued criticism from the bourgeois Parisians and their self-righteous indignation, Sargent decided to leave Paris and move on to the more cosmopolitan and broad-minded England, specifically, London. Nevertheless, the painting remained his personal favorite, and *Madame X* was displayed in his studio for over 30 years to remind his fashionable clients just how edgy he was.

Mme. Gautreau hated the painting at first because it was responsible for ruining her reputation, but with time grew proud of it, allowing herself to be painted by two other artists, Gustave Courtois in 1891 and Antonino de la Gandara in 1898. Sargent eventually sold the painting to the Metropolitan Museum in New York in 1916 for the very low price of £1,000. He insisted that the sitter's name remain anonymous, but remarked: "I suppose it is the best thing I have done."

Before he left France, Sargent already had commissions in England to paint a number of portraits for the Vickers family. He hired a studio in Kensington, London. In time he took out a lease on a house at 13 Tite Street in Chelsea, which was Whistler's old studio. He remained downcast for months from his critical disaster, but rallied soon, sending paintings to the Royal Academy for exhibition. In this way, he gained an enviable reputation. As a consequence, he received many substantial commissions to paint members of British high society, such as Mrs. Cecil Wade and Joseph Chamberlain. His good friend Henry James, the novelist, remarked of Sargent that he showed "the slightly 'uncanny' spectacle of a talent which on the very threshold of its career has nothing more to learn." Some years later, in 1913, as a 70th birthday present, Sargent painted James's portrait.

In 1885, the American painter, sculptor, and friend of Sargent, Francis David Millet, invited Sargent to visit him at his home in the small village of Broadway in Worcestershire where a thriving artists' colony had taken root.

While Millet's guest, Sargent began his famous masterpiece, *Carnation, Lily, Lily, Rose.* The inspiration for the work occurred a year earlier when he saw two children playing in the garden of Lavington Rectory around huge white lilies. He had also been struck by the magical quality of hanging lanterns along the Thames at Pangborne. Initially, he used Millet's daughter, Katherine, as one of his models, but she was too young to pose for any length of time, so he chose 11-year-old Dorothy (Dolly), who is at the left in the painting, and 7-year-old Polly Barnard, two sisters who had the

hair color he desired for the painting.

The most ambitious part of his design was to capture the two fleeting minutes at twilight when the sunset throws a mauve light, but there is just enough gloom for the lit Chinese paper lanterns to glow. Furthermore, he wanted to paint at that same exact moment, outside in the fresh air. The evolution of the painting was watched with considerable interest by the Broadway artists' colony at Lavington. From September to early November 1885, his work continued. When the weather got colder, the children wore long white sweaters, which they removed at the last possible moment. Artificial flowers had to be procured from the London department store Marshall & Snelgrove because the real flowers died with the approaching winter.

Sergeant resumed work on the painting the following summer. *Carnation, Lily, Lily, Rose* was finally completed in October 1886. Eventually, Sargent cut off two feet from the left side of the canvas to focus attention on the subjects and square up the picture.

When the painting was exhibited in London at the Royal Academy in 1887, it was a roaring success. The Tate Gallery immediately purchased it for £700. The title of the work was taken from the lyrics of a popular song, "The Wreath," composed by Joseph Mazzinghi.

By 1886, London had become Sargent's permanent home, and he gave up his Paris studio to fellow artist Giovanni Boldini. Wealthy enough to live a comfortable life, a favorite lunchtime location was the Hans Crescent Hotel where he would indulge his "gargantuan appetite." Indeed, in middle age he became quite large.

Sargent returned to France in 1887 and stayed with Monet at his famously beautiful garden at Giverny. He had stayed there earlier when he painted *Claude Monet Painting at the Edge of a Wood* (1885) in an Impressionistic style. The pair enjoyed working together and in 1888 Monet came to visit Sargent in London. This visit was rapidly followed by Sargent's first professional journey to America where Henry C. Marquand (soon to be the Metropolitan Museum of Art president) wanted him to paint his wife in Newport, Rhode Island. In an attempt to avoid taking the commission, Sargent had tripled his fee, but this higher fee was accepted, requiring Sargent to make the journey to America. The work was a success and soon he was in great demand with American high society. Among others, he painted portraits of the members of the Vanderbilt family. He raised his prices again and still the commissions rolled in.

By the 1890s, Sargent was averaging 14 commissioned portraits a year and was the top society painter of his day. Sargent insisted on choosing the costumes and accessories of his sitters and would not flatter his subjects to please their ego. After painting the consummate portrait, *Lady Agnew of Lochnaw* in 1892, he became as sought after in London as in New York. Edward VII was such a fan

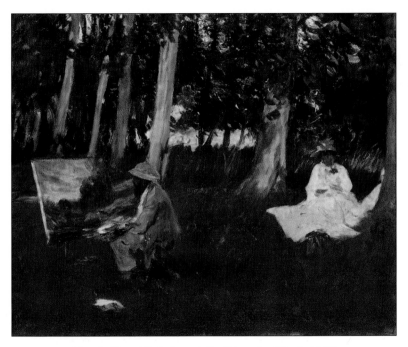

Claude Monet Painting at the Edge of a Wood, 1885

that he offered Sargent a knighthood in 1907, but Sargent gracefully declined on the grounds that he was an American citizen. In 1902, the great French sculptor Rodin described him as "the Van Dyck of our times."

In 1894, Sargent was elected an associate member of the Royal Academy and became a full member in 1897. By then he was a regular exhibitor as well as a teacher at the Royal Academy. His reputation was secure. His fame had long since spread back to the United States, and he was soon regularly crossing the Atlantic for professional reasons. Sargent was elected in 1897 an academician at the National Academy of Design in New York, and in 1889, the French made him a Chevalier of the Légion d'Honneur. By the time of his death, Sargent had been awarded 30 prestigious degrees and decorations from Britain, America, France, Belgium, and Germany.

On a trip to the United States in 1890, he was asked to decorate the Special Collections Hall for the Boston Public Library's new building designed by Charles McKim. He agreed and, after much thought, he picked religion as his theme for murals eventually titled *Triumph of Religion.*

The project was expanded until Sargent was also commissioned to paint murals for all four walls of the hallway. The project ultimately took 25 years. It was finally finished and installed in 1919.

Admiring the progress of this enormous project, the nearby Museum of Fine Arts in Boston commissioned Sargent to design ceiling decorations for their rotunda. Again, the results were so well received that the trustees asked him to decorate the stairway with murals as well. Working on these huge murals required more studio space, so Sargent took a larger studio at 12–14 The Avenue, Fulham Road, a short walk from his home.

During the first decade of the new century, Sargent was constantly in demand, but was by then finding the endless portraits drudgery. He traveled at every possible opportunity, often with friends and almost always with one or both of his sisters and their children. He loved Italy, and Venice and Rome were particular favorites. Seeking new inspiration, Sargent took his mother (now a widow) and sisters to Egypt, Greece, Turkey, the Middle East, and North Africa. Travel was simply a passion he enjoyed all of his life. In 1906, when he heard of his mother's death, he was in Jerusalem and had to hurry home for her funeral, which was delayed at his request.

Comfortable financially and not needing to work commercially any longer, Sargent virtually gave up portrait commissions after 1907. Sargent felt that he had more interesting and challenging projects at hand. He turned to landscapes, and even took up sculpture in later years. In 1909, he exhibited 86 watercolors in New York City, and the Brooklyn Museum bought all but 3 of them.

Despite his declaration never to make any portrait paintings again—apart from those he had already agreed to do—between 1890 and 1916 Sergeant bowed somewhat to the demands of his wealthy patrons and for a fee would make rapid

charcoal portraits which he called "Mugs." In 1916, the Royal Society of Portrait Painters exhibited 46 of the Mugs. And he could hardly refuse in 1910 when he was summoned to make a charcoal sketch of King Edward VII on his deathbed. He had painted the portrait of President Theodore Roosevelt in 1903 and, as with Edward VII's request, he accepted the commission to paint President Woodrow Wilson's portrait in 1917.

When war broke out in 1914 it was no longer possible for Sargent to travel around Europe so freely and he spent much of his time in the United States working on his various commissions, staying for two full years in 1915–17.

In 1918, the British War Office sent Sargent, at the age of 62, to France as an official war artist after commissioning him for a large work to hang in the Hall of Remembrance to commemorate Anglo-American cooperation. He traveled with fellow war artist Henry Tonks, a medically trained old friend and principal of the Slade School. Together they made the perilous journey to the Western Front in July 1918 where they witnessed the awful realities of the war, observing and sketching the destruction and death, the ruins and the despair of the people and soldiers alike. One day Sargent visited a casualty station at Le Bac-de-Sud during the aftermath of a German mustard gas attack on the British 8th and 99th Brigades of the 2nd and 3nd Divisions. It inspired his next great work.

In all, Sargent spent four months in France observing and making preliminary sketches. On his return to England, he painted his most moving masterpiece, *Gassed* (1918–19). The resulting painting was 20-feet long and shows a line of blindfolded, stumbling, and shattered men guiding each other toward a field dressing station. In the foreground lie the non-mobile victims of the savage attack, and in the background, a game of football is taking place. Sargent took a nominal fee of £300 for the masterpiece and it was hung at the Imperial War Museum in London.

In fall 1921, the president of Harvard, Abbott Lawrence Lowell, commissioned Sargent to paint a commemorative war memorial on two panels for the main stairwell of Widener Library. Sargent produced them in his studio in London and sent them on when ready. The last one was finished and sent in 1925. Sargent was packing to follow the panels to Boston and supervise their installation. It is said that he made a humorous remark to a friend that "Now the American things are done, and so, I suppose, I may die when I like." Just a few days later on April 15, 1925, he died at home in his sleep on Tite Street, London, of a heart attack. He was 69 years old. He left no children. Sargent had many friends but never acknowledged a lover of either sex. His personal preferences have been much debated by art historians, but no conclusion has been reached.

John Singer Sargent was buried at Brookwood Cemetery in Woking, England, on April 18, 1925. His tombstone reads: Laborare Est Orare–Labor is prayer.

Plate 1

FISHING FOR OYSTERS AT CANCALE
1878, Museum of Fine Arts Boston
40.96 x 60.96 cm

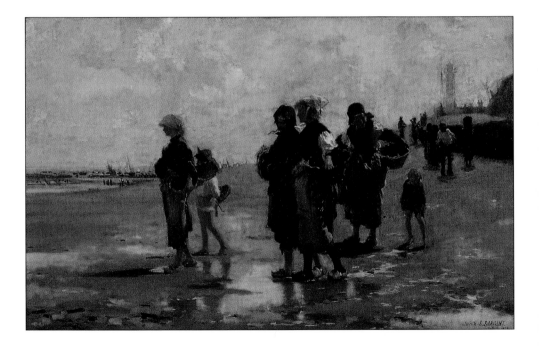

FUMÉE D'AMBRE GRIS (SMOKE OF AMBERGRIS)

1880, Sterling and Francine Clark Art Institute, Williamstown, Massachusetts
139.1 x 90.6 cm

Plate 2

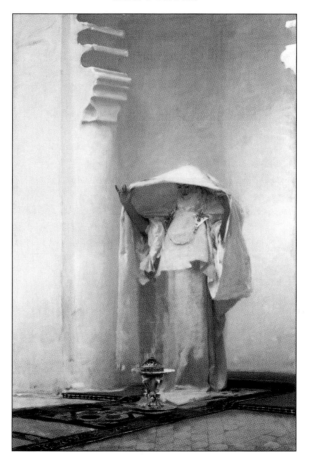

Plate 3

RAMÓN SUBERCASSAUX

1880, Dixon Gallery, Memphis, Tennessee
47 x 63.5 cm

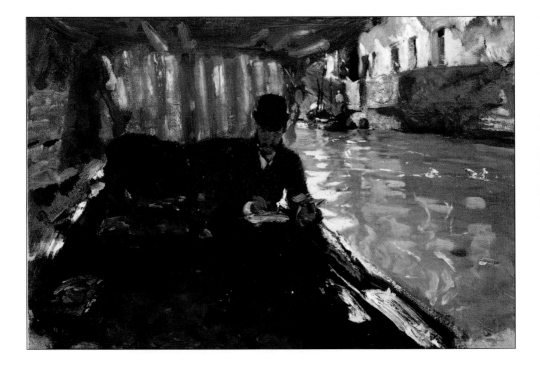

A VENETIAN WOMAN
1882, Cincinatti Museum of Art, Ohio
238.2 x 133 cm

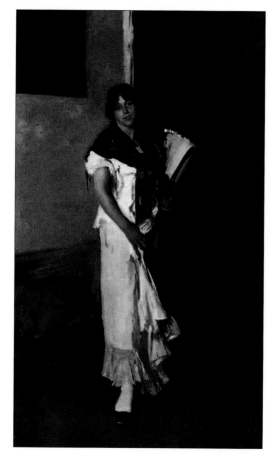

Plate 4

Plate 5

EL JALEO

1882, Isabella Stewart Gardner Museum, Boston
232 x 348 cm

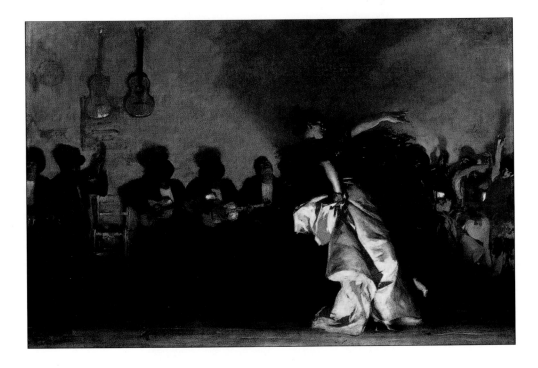

MADAME GAUTREAU DRINKING A TOAST

1882–83, Isabella Stewart Gardner Museum, Boston

32 x 41 cm

Plate 6

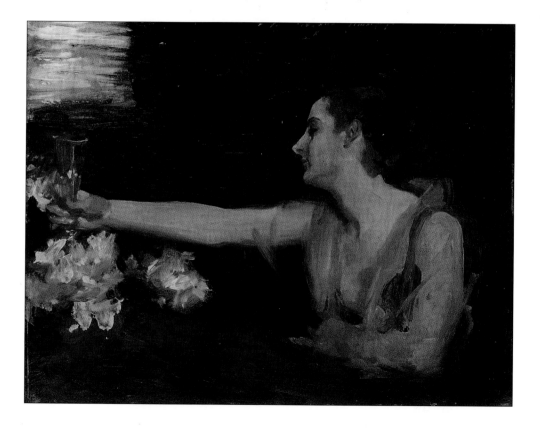

Plate 7

MARGARET STUYVESANT RUTHERFURD WHITE

1883, Corcoran Gallery of Art, Washington, DC
223.5 x 142.9 cm

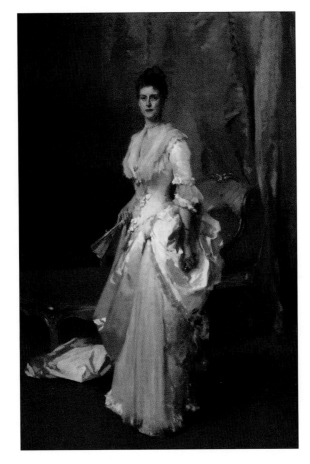

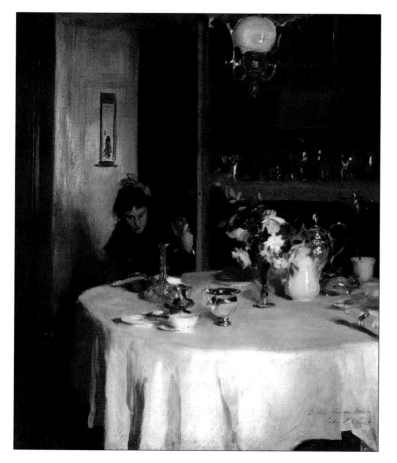

THE BREAKFAST TABLE
1883–84, Fogg Art Museum, Cambridge, Massachusetts
54 x 45 cm

Plate 8

Plate 9

CAROLINE DE BASSANO, MARQUISE D'ESPEUILLES

1884, de Young, Fine Arts Museums of San Francisco
159.7 x 105.1 cm

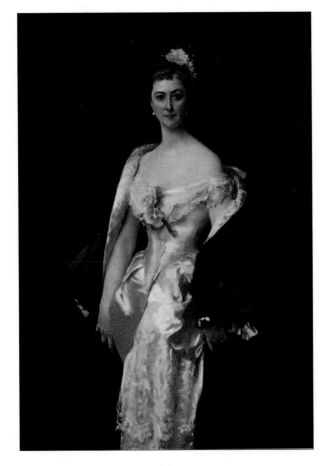

Plate 10

PORTRAIT OF RODIN
1884, Musée Rodin, Paris
72 x 53 cm

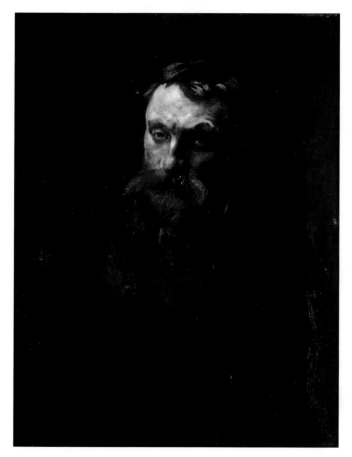

Plate 11

A DINNER TABLE AT NIGHT
1884, de Young, Fine Arts Museums of San Francisco
51.4 x 66.7 cm

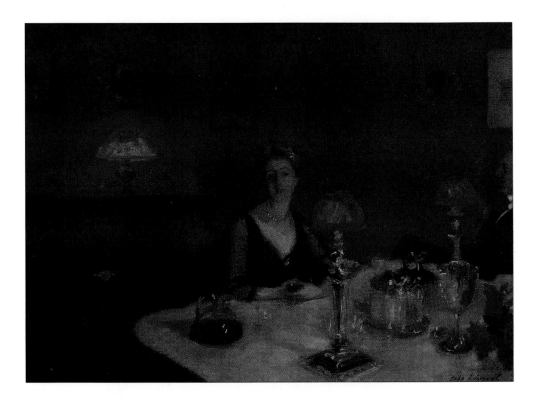

MADAME X (MADAME PIERRE GAUTREAU) *Plate 12*

1883–84, Metropolitan Museum of Art, New York City
208.6 x 109.9 cm

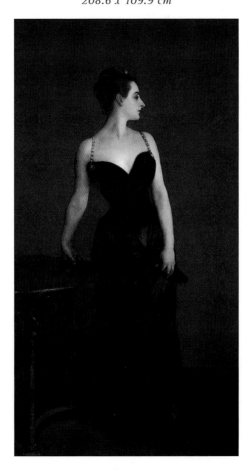

Plate 13

MADAME PAUL POIRSON

1885, Detroit Institute of Arts, Michigan
152.4 x 86.4 cm

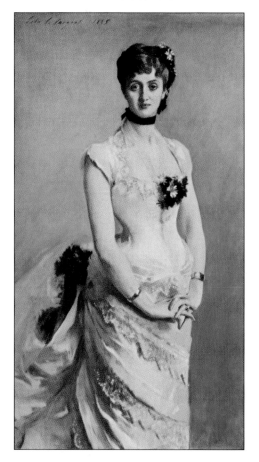

Plate 14

CARNATION, LILY, LILY, ROSE
1885-6, Tate Britain, London
174 x 153.7 cm

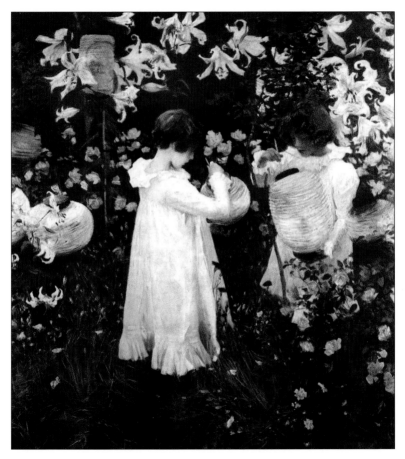

Plate 15

PORTRAIT OF ISABELLA STEWART GARDNER

1888, Isabella Stewart Gardner Museum, Boston
190 x 80 cm

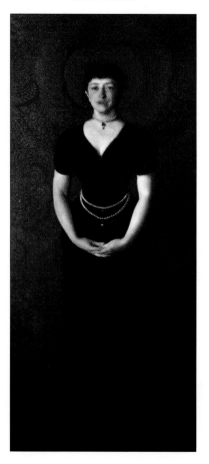

ELLEN TERRY AS LADY MACBETH

1889, Tate Britain, London
221 x 114.3 cm

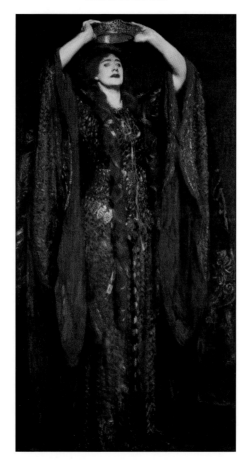

Plate 16

Plate 17

LA CARMENCITA
1890, Musée d'Orsay, Paris
232 x 142 cm

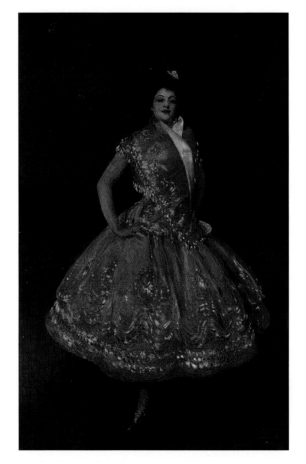

Plate 18

EGYPTIANS RAISING WATER FROM THE NILE

1890–91, Metropolitan Museum of Art, New York City
63.5 x 53.3 cm

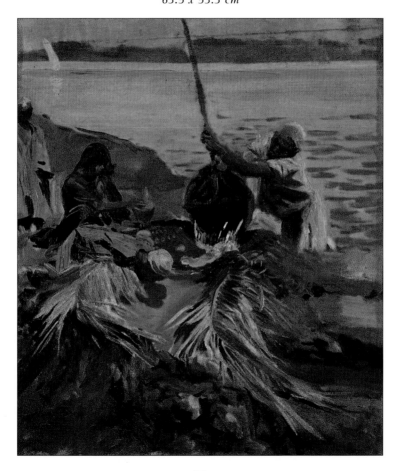

Plate 19

MRS. HUGH HAMMERSLEY

1892, Metropolitan Museum of Art, New York City
205.7 x 115.6 cm

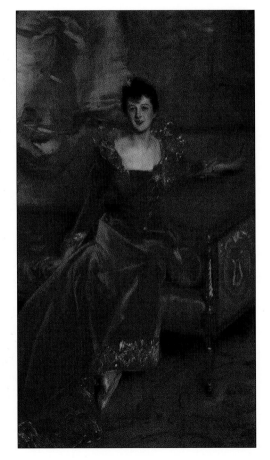

LADY AGNEW OF LOCHNAW

1892, Scottish National Gallery, Edinburgh
127 x 101 cm

Plate 20

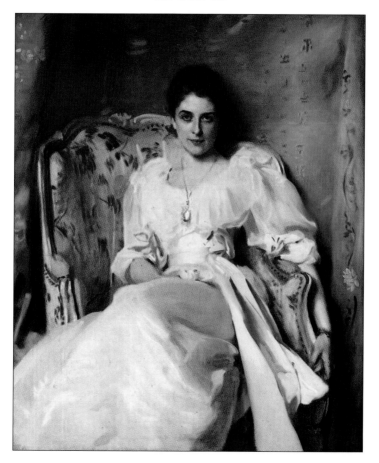

Plate 21

ELIZABETH WINTHROP CHANLER

1893, Smithsonian American Art Museum, Washington, DC
125.4 x 102.9 cm

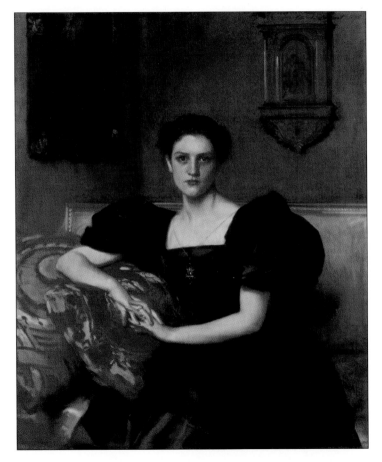

COVENTRY KERSEY DEIGHTON PATMORE

1894, National Portrait Gallery, London
91.4 x 61 cm

Plate 22

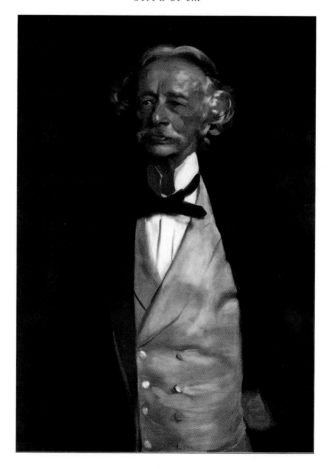

Plate 23

HELEN SEARS

1895, Museum of Fine Arts Boston
167.3 x 91.4 cm

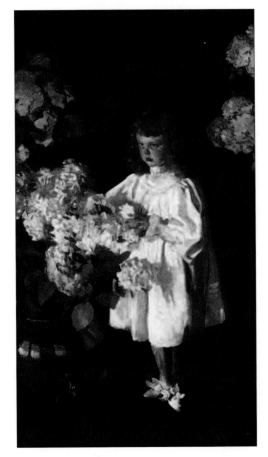

JEAN, WIFE OF COLONEL IAN HAMILTON

Plate 24

1896, Tate Britain, London
130.2 x 92.1 cm

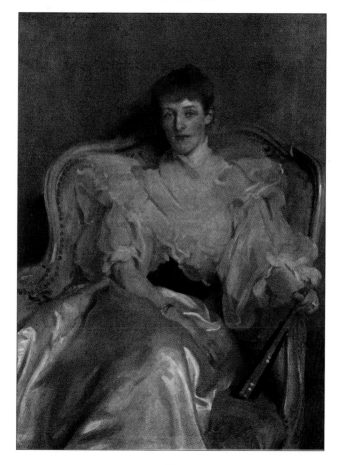

Plate 25

PRINCESS DEMIDOFF
c. 1895-96, Toledo Museum of Art, Ohio
167 x 97 cm

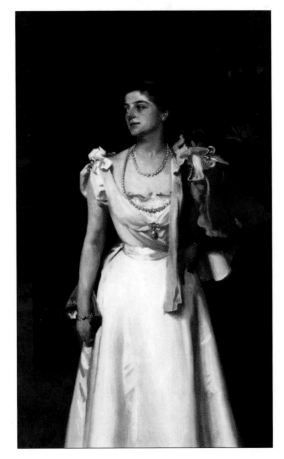

CATHERINE VLASTO

Plate 26

1897, Hirshhorn Museum and Sculpture Garden, Smithsonian Institution, Washington, DC
148.6 x 85.3 cm

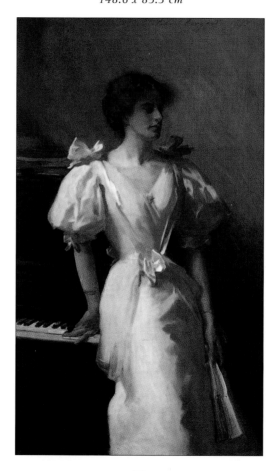

Plate 27 MRS. GEORGE SWINTON (ELIZABETH EBSWORTH)

1897, Art Institute of Chicago
231 x 124 cm

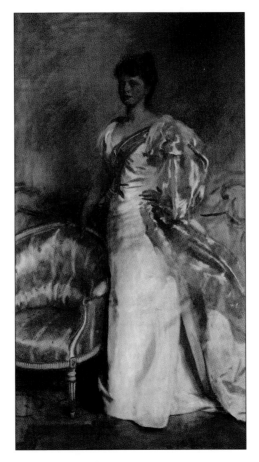

HENRY G. MARQUAND

1897, Metropolitan Museum of Art, New York City
132.1 x 106 cm

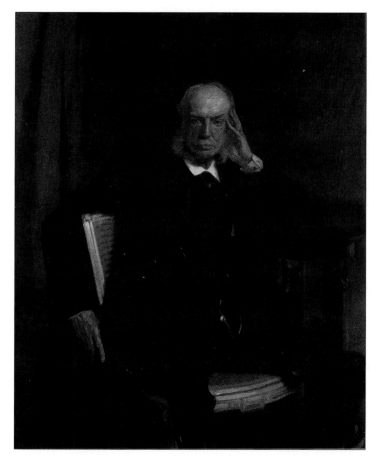

Plate 28

Plate 29

PORTRAIT OF LISA COLT CURTIS

1898, Cleveland Museum of Art, Ohio
249 x 139 cm

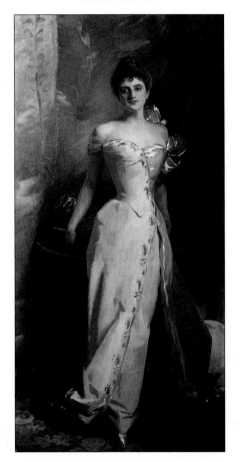

COLONEL IAN HAMILTON

1898, Tate Britain, London
138.4 x 78.7 cm

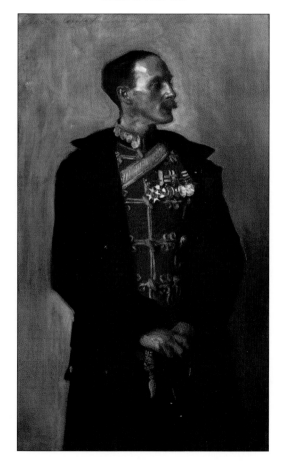

Plate 30

Plate 31

AN INTERIOR IN VENICE

1899, Royal Academy of Arts, London
66 X 83.5 cm

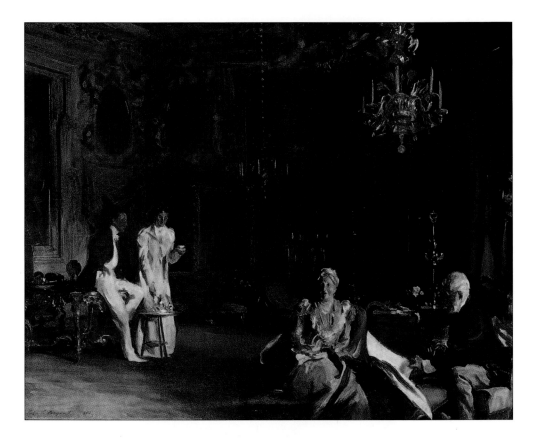

THE WYNDHAM SISTERS

Plate 32

1899, Metropolitan Museum of Art, New York City
292.1 x 213.7 cm

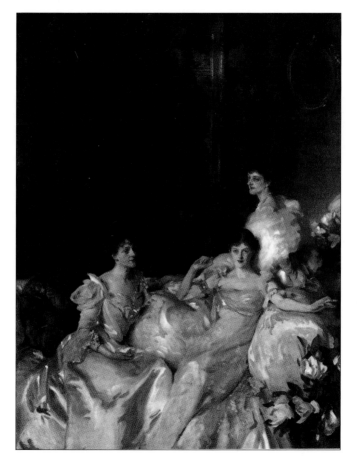

Plate 33

ON HIS HOLIDAYS

1901–02, Lady Lever Art Gallery, National Museums Liverpool, UK
137 x 244 cm

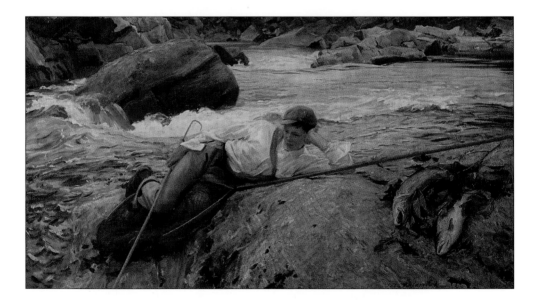

ENA AND BETTY, DAUGHTERS OF
ASHER AND MRS. WERTHEIMER

1901, Tate Britain, London
185.4 x 130.8 cm

Plate 34

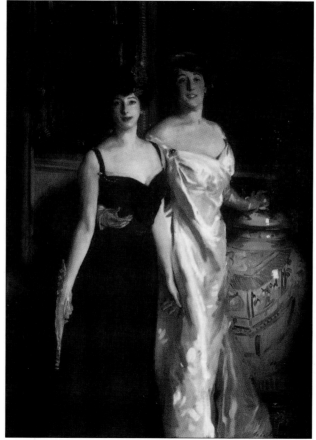

Plate 35

ALFRED, SON OF ASHER WERTHEIMER

c. 1901, Tate Britain, London
163 x 115 cm

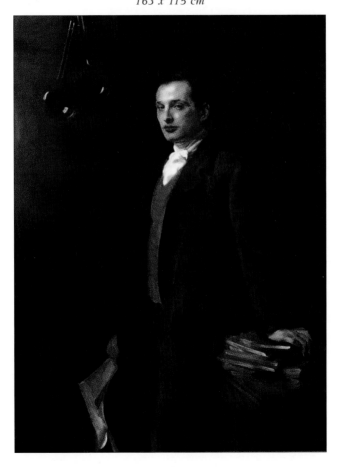

Plate 36

HYLDA, DAUGHTER OF ASHER AND MRS WERTHEIMER

1901, Tate Britain, London
214.6 x 143.5 cm

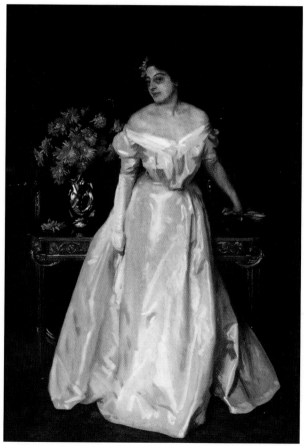

Plate 37

ESSIE, RUBY AND FERDINAND,
CHILDREN OF ASHER WERTHEIMER

1902, Tate Britain, London
161.5 x 193.5 cm

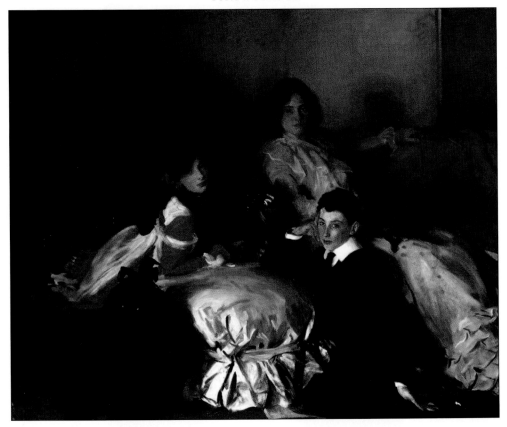

Plate 38

MARY CROWNINSHIELD ENDICOTT CHAMBERLAIN

1902, Natinal Gallery of Art, Washington, DC
150.5 x 83.8 cm

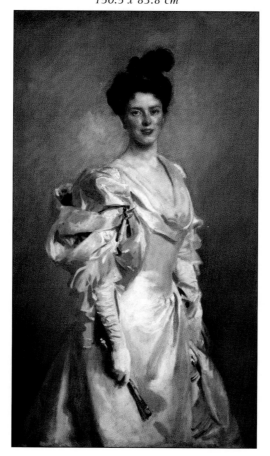

Plate 39

PORTRAIT OF MRS. LEOPOLD HIRSCH
1902, Tate Britain, London
145 x 90 cm

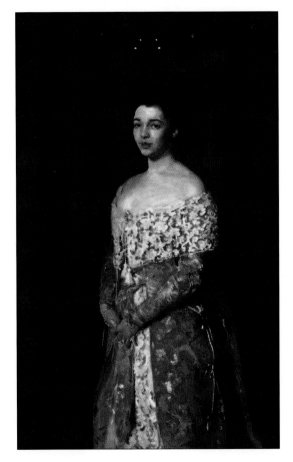

Plate 40

EVELYN BARING, 1ST EARL OF CROMER
1902, National Portrait Gallery, London
148.8 mm x 98.4 cm

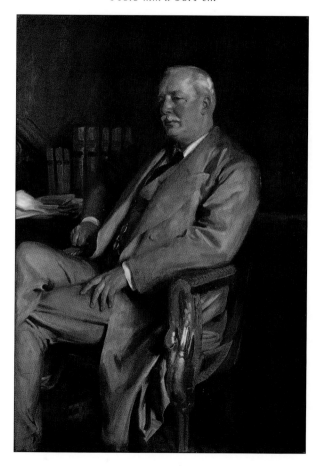

Plate 41

THE MISSES HUNTER

1902, Tate Britain, London
229.2 x 229.9 cm

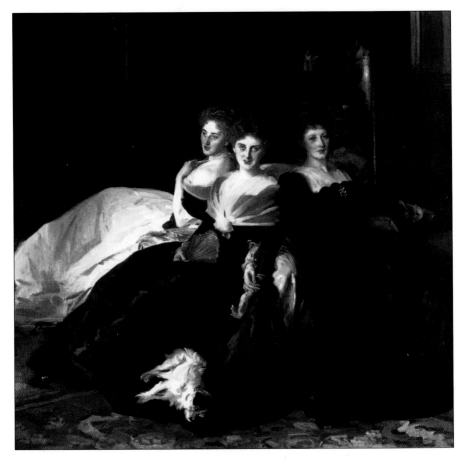

EDWARD ROBINSON

1903, Metropolitan Museum of Art, New York City
143.5 x 92.1 cm

Plate 42

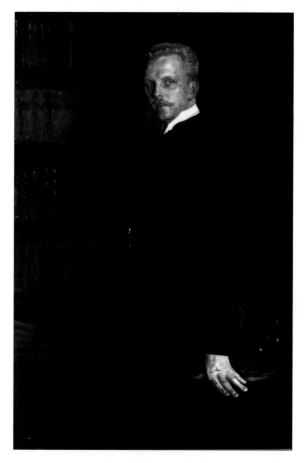

Plate 43

PORTRAIT OF MRS. A. LAWRENCE ROTCH

1903, Joslyn Art Museum, Omaha, Nebraska
144.2 x 92.1 cm

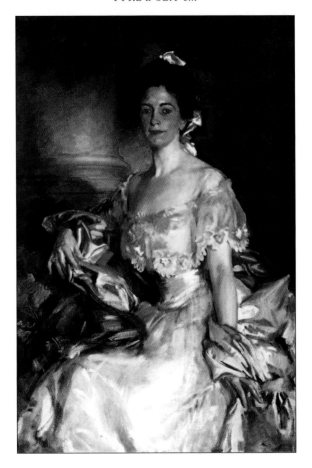

ELLEN SEARS AMORY ANDERSON CURTIS

Plate 44

1903, Portland Museum of Art, Maine
152.2 x 76.2 cm

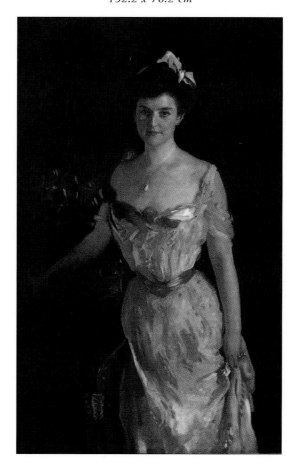

Plate 45

AN ARTIST IN HIS STUDIO

1904, Museum of Fine Arts Boston
56.2 x 72.07 cm

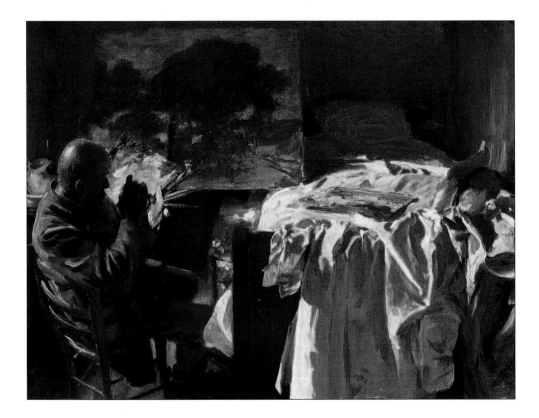

VENETIAN INTERIOR

Plate 46

Before 1904, Philadelphia Museum of Art
24.9 x 35.2 cm

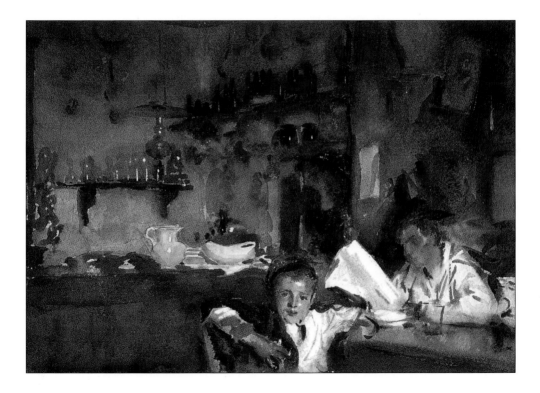

Plate 47

THE COUNTESS OF LATHOM
1904, Chrysler Museum of Art, Norfolk, Virginia
228 x 171.8 cm

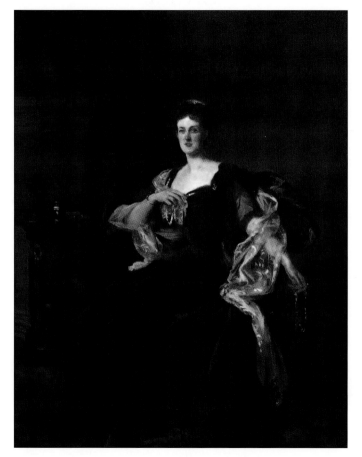

Plate 48

PORTRAIT OF MILLICENT, DUCHESS OF SUTHERLAND

1904, Museo Thyssen-Bornemisza, Madrid
254 x 146 cm

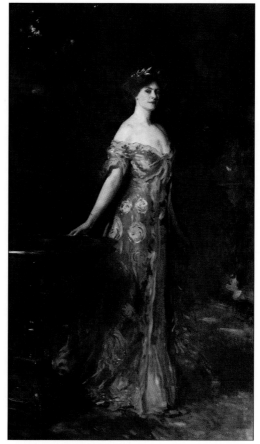

Plate 49

A TRAMP

c. 1904–06, Brooklyn Museum of Art, New York City
50.8 x 35.6 cm

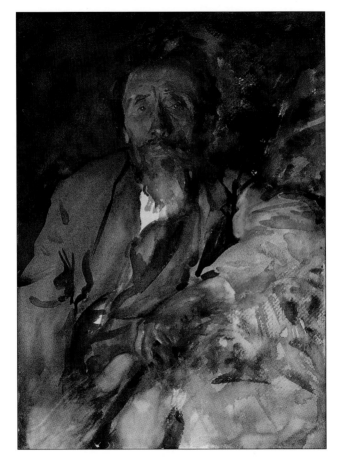

HILLS OF GALILEE

c. 1905–06, Brooklyn Museum of Art, New York City
30.5 x 45.7 cm

Plate 50

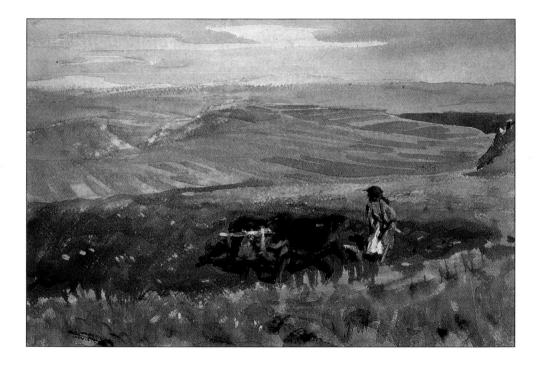

Plate 51

BEDOUINS

c. 1905–06, Brooklyn Museum of Art, New York City
45.7 x 30.5 cm

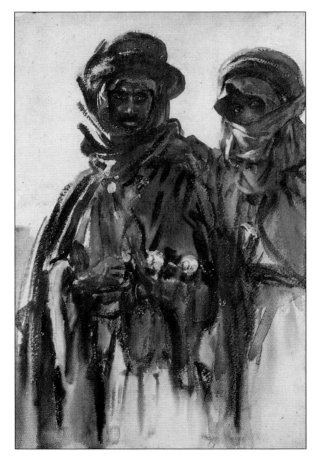

Plate 52

ARAB STABLE
c. 1905–06, Brooklyn Museum of Art, New York City
26.5 x 36.5 cm

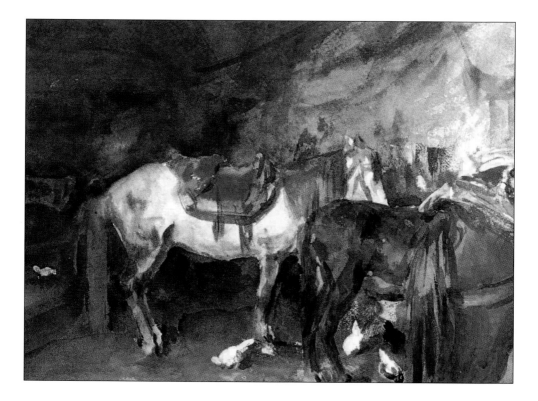

Plate 53

VENETIAN PASSAGEWAY

c. 1905, Metropolitan Museum of Art, New York City
53.8 x 36.8 cm

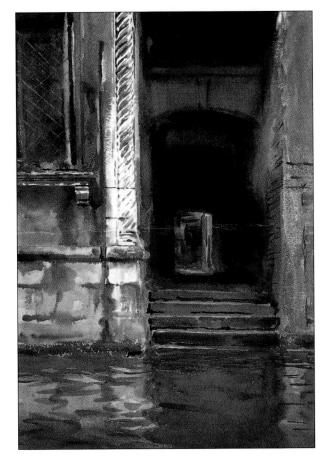

VIOLET SLEEPING

Plate 54

c. 1907–08, Brooklyn Museum of Art, New York City
37.3 x 54.1 cm

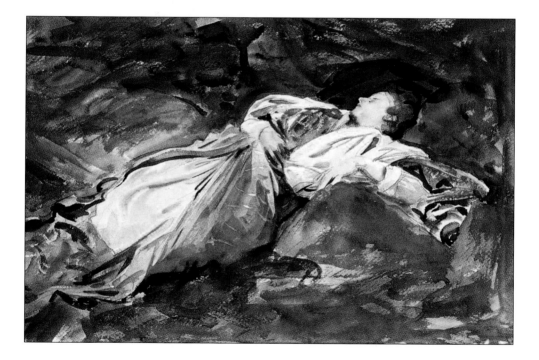

Plate 55

THE FOUNTAIN, VILLA TORLONIA, FRASCATI, ITALY

1907, Art Institute of Chicago

71.4 x 56.5 cm

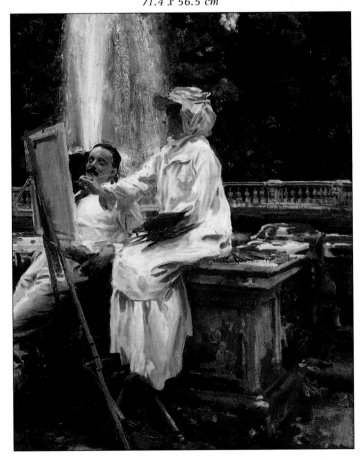

MATHILDE TOWNSEND

1907, National Gallery of Art, Washington, DC
152.7 x 101.6 cm

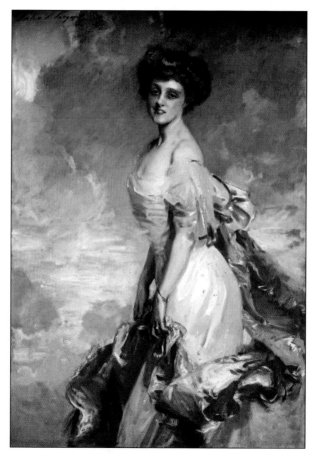

Plate 56

Plate 57

MOSQUITO NETS
1908, Detroit Institute of Arts, Michigan
57.2 x 71.8 cm

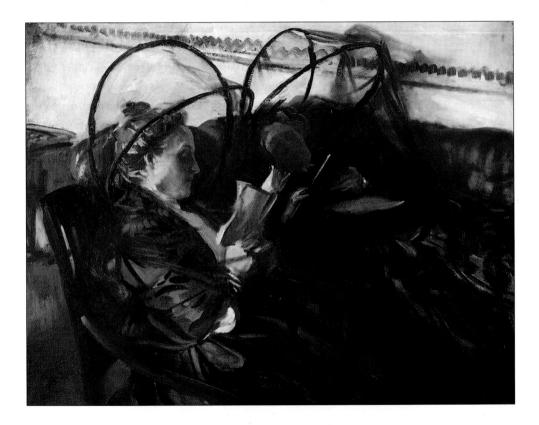

ALMINA, DAUGHTER OF ASHER WERTHEIMER

Plate 58

1908, Tate Britain, London
134 x 101 cm

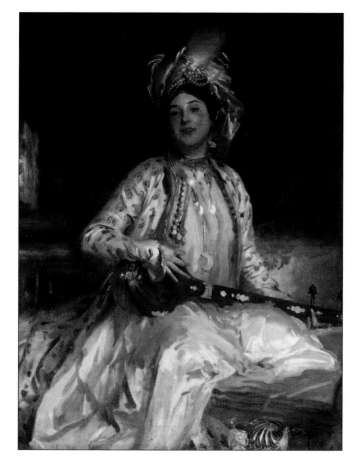

Plate 59

THE OLIVE GROVE
1908, Indianapolis Museum of Art, Indiana
56.2 x 73.03 cm cm

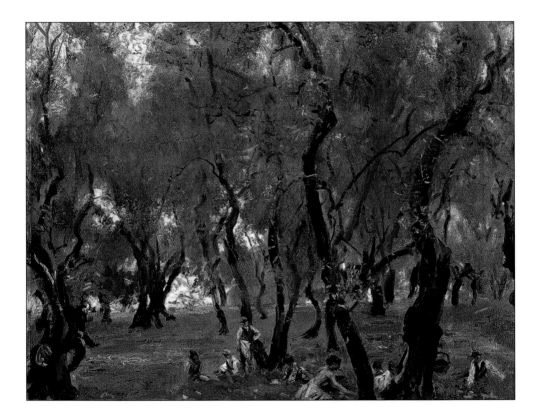

CORFU: LIGHTS AND SHADOWS

1909, Museum of Fine Arts Boston
40.3 x 53.1 cm

Plate 60

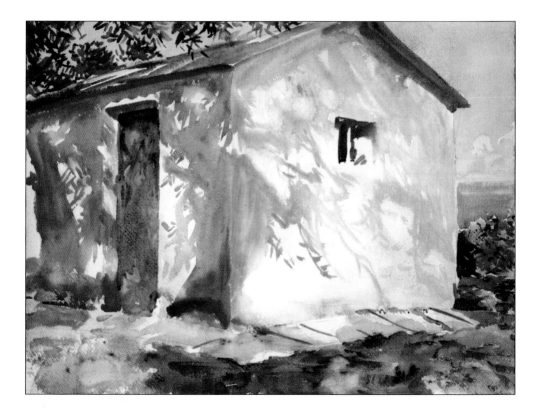

Plate 61

IN THE SIMPLON PASS

1909, Brooklyn Musuem of Art, New York City
36.7 x 53.8 cm

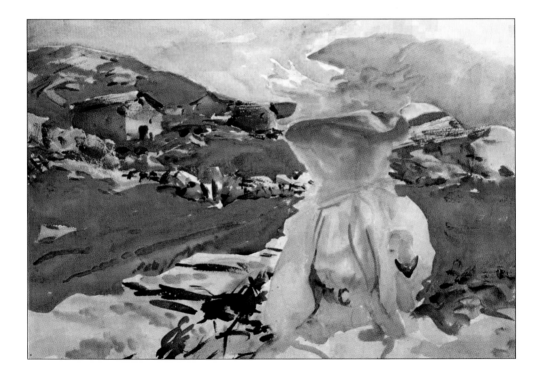

LA BLANCHERIA

1910, Museum of Fine Arts Boston
40.4 x 53.1 cm

Plate 62

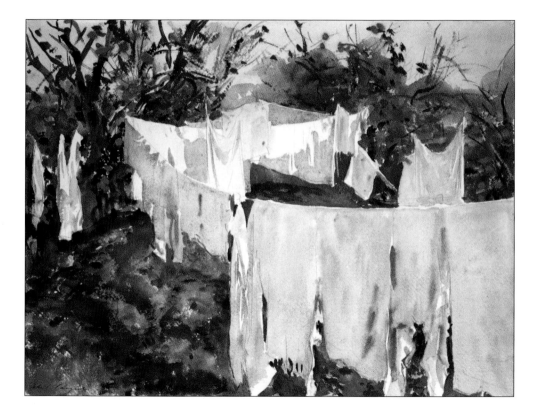

Plate 63

STUDY OF ARCHITECTURE, FLORENCE

c. 1910, Fine Arts Museum of San Francisco
71.1 x 88.9 cm

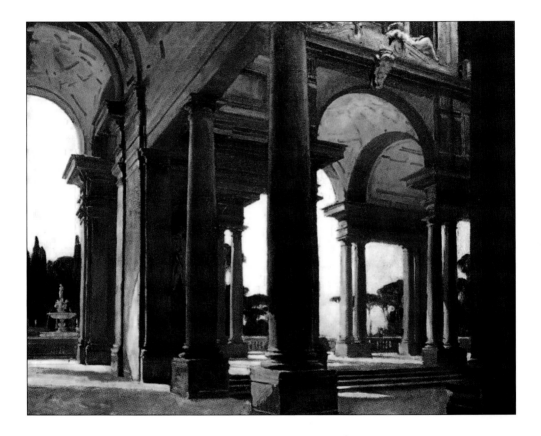

Plate 64

AT TORRE GALLI: LADIES IN A GARDEN

1910, Royal Academy of Arts, London
71.1 x 91.5 cm

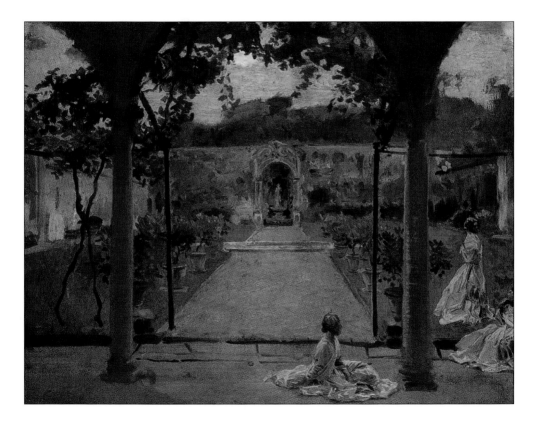

Plate 65

THE GARDEN WALL
1910, Museum f Fine Arts Boston
40.2 x 53 cm

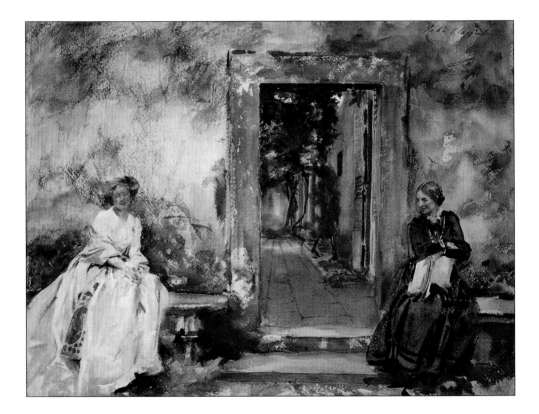

NONCHALOIR (REPOSE)
1911, National Gallery of Art, Washington, DC
63.8 a 76.2 cm

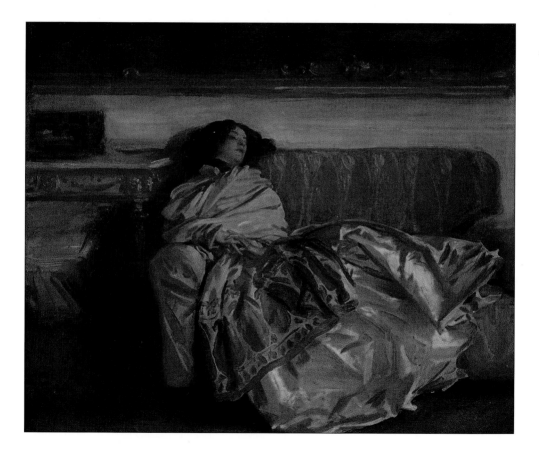

Plate 66

Plate 67

SIMPLON PASS READING
1911, Museum of Fine Arts Boston
51 x 35.7 cm

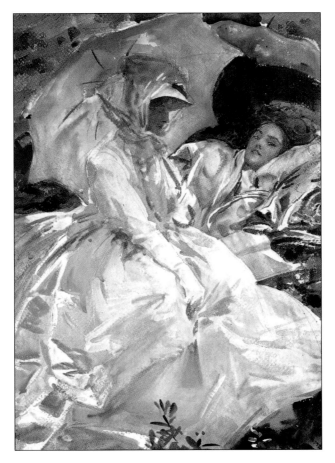

IN THE GENERALIFE, GRANADA

1912, Metropolitan Museum of Art, New York City
37.5 x 45.4 cm

Plate 68

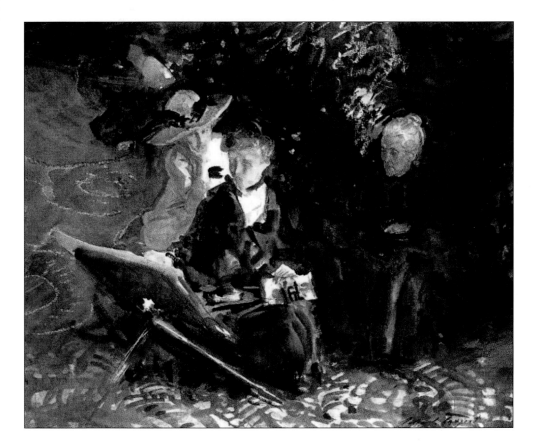

Plate 69

HENRY JAMES
1913, National Gallery, London
85.1 x 67.3 cm

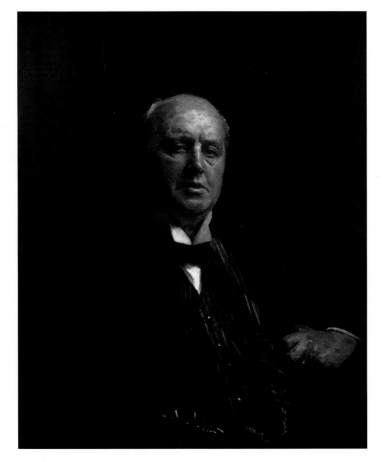

Plate 70

THE SKETCHERS

c. 1913, Virginia Museum of Fine Arts, Richmond
55.9 x 71.1 cm

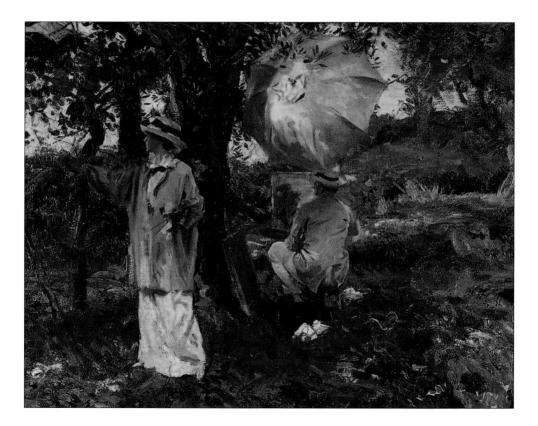

Plate 71

ESCUTCHEON OF CHARLES V OF SPAIN
1912, Metropolitan Museum of Art, New York City
30.5 x 45.7 cm

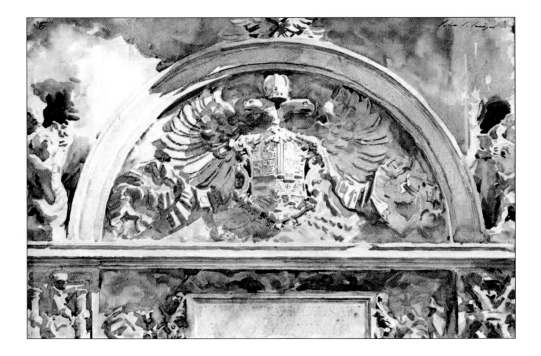

GRANADA

Plate 72

1912, Metropolitan Museum of Art, New York City
40 x 53 cm

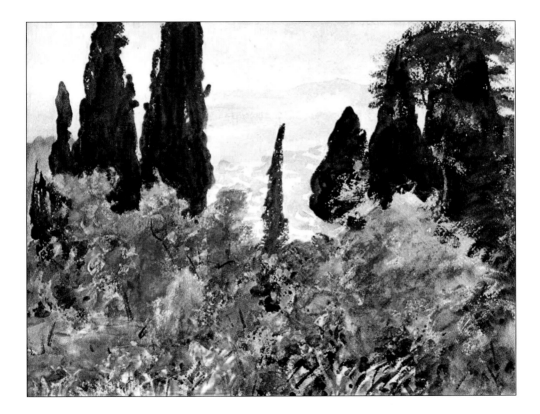

Plate 73

TROUT STREAM IN THE TYROL
1914, de Young, Fine Arts Museums of San Francisco
55.9 x 71.1 cm

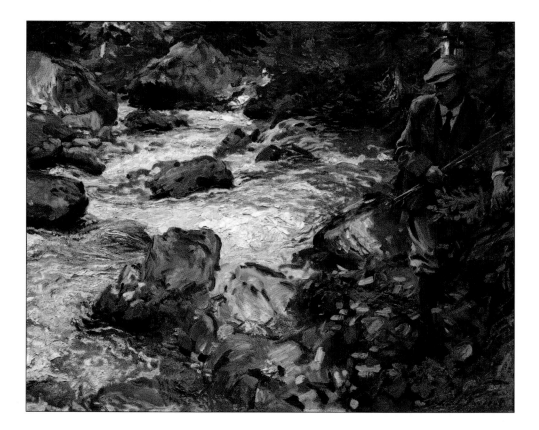

MOUNTAIN STREAM
Plate 74

c. 1912–14, Metropolitan Museum of Art, New York City
34.8 x 53.3 cm

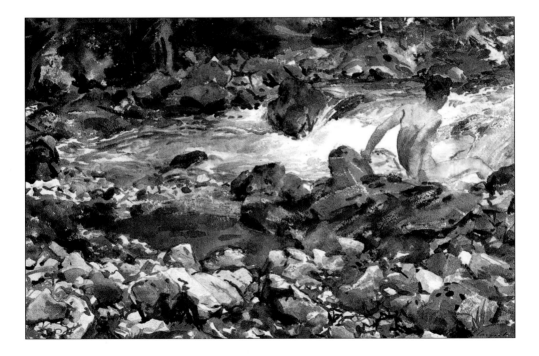

Plate 75

MUDDY ALLIGATORS
1917, Worcester Art Museum, Massachusetts
35.5 x 53 cm

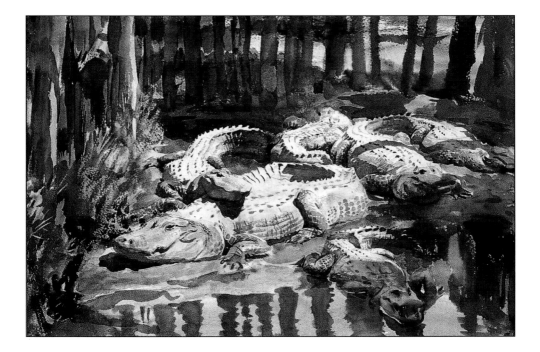

Plate 76

PALMETTOS
1917, Metropolitan Museum of Art, New York City
38.7 x 52.7 cm

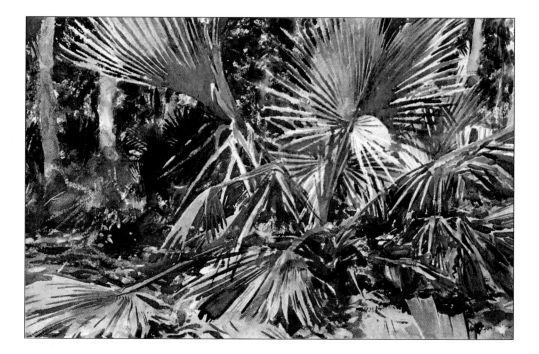

Plate 77

THOU SHALT NOT STEAL

1918, Imperial War Museums, London
50.8 x 33.6 cm

GASSED

1918, Imperial War Museums, London
231 x 611.1 cm

Plate 78

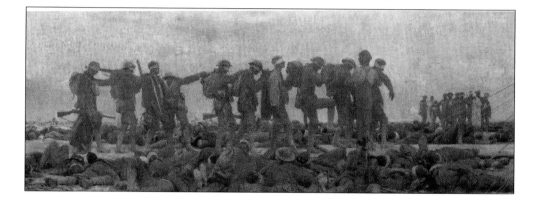

Plate 79

MRS. GARDNER IN WHITE

1922, Isabella Stewart Gardner Museum, Boston
43 x 32 cm

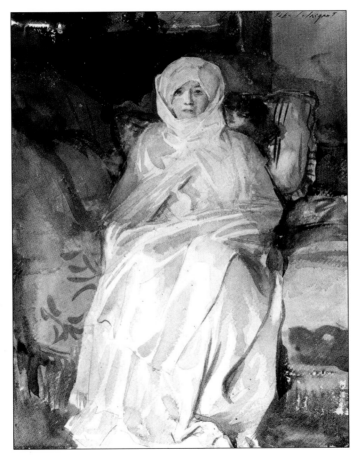

GENERAL OFFICERS OF WORLD WAR I

1922, National Portrait Gallery, London
299.7 x 528.3 cm

Plate 80

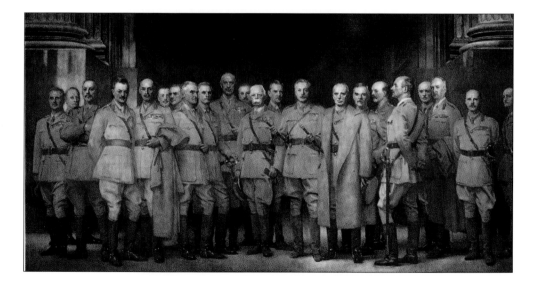

Plate 81

SIR PHILIP SASSON

1923, Tate Britain, London
95.2 x 57.8 cm

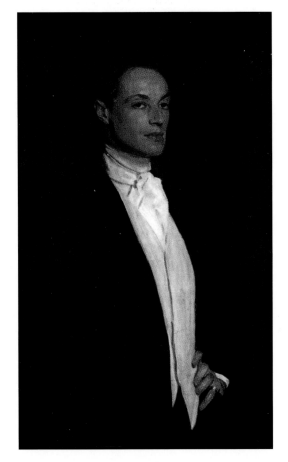

GRACE ELVINA,
MARCHIONESS CURZON OF KEDLESTON

1925, Currier Gallery of Art
129.22 cm x 92.39 cm

Plate 82

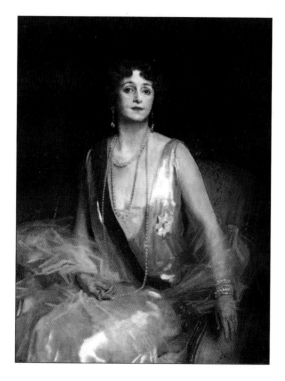

INDEX

A Dinner Table at Night	24
A Tramp	62
A Venetian Woman	17
Alfred, Son of Asher Wertheimer	48
Almina, Daughter of Asher Wertheimer	71
An Artist in His Studio	58
An Interior in Venice	44
Arab Stable	65
At Torre Galli: Ladies in a Garden	77
Bedouins	64
Breakfast Table, The	21
Carnation, Lily, Lily, Rose	27
Caroline de Bassano, Marquise d'Espeuilles	22
Catherine Vlasto	39
Colonel Ian Hamilton	43
Corfu: Lights and Shadows	73
Countess of Lathom, The	60
Coventry Kersey Deighton Patmore	35
Edward Robinson	55
Egyptians Raising Water from the Nile	31
El Jaleo	18
Elizabeth Winthrop Chanler	34
Ellen Sears Amory Anderson Curtis	57
Ellen Terry as Lady Macbeth	29
Ena and Betty, Daughters of Asher and Mrs. Wertheimer	47
Escutcheon of Charles V of Spain	84
Essie, Ruby and Ferdinand (Wertheimer)	50
Evelyn Baring, 1st Earl of Cromer	53
Fishing for Oysters at Cancale	14
Fountain, Villa Torlonia, Frascati, Italy, The	68
Fumée d'Ambre Gris (Smoke of Ambergris)	15
Garden Wall, The	78
Gassed	91
General Officers of World War I	93
Grace Elvina, Marchioness Curzon of Kedleston	95
Granada	85
Helen Sears	36
Henry G. Marquand	41
Henry James	82
Hills of Galilee	63
Hylda, Daughter of Asher and Mrs Wertheimer	49
In the Generalife, Granada	81
In the Simplon Pass	74
Jean, Wife of Colonel Ian Hamilton	37
La Blancheria	75
La Carmencita	30
Lady Agnew of Lochnaw	33
Madame Gautreau Drinking a Toast	19
Madame Paul Poirson	26
Madame X (Madame Pierre Gautreau)	25
Margaret Stuyvesant Rutherfurd White	20
Mary Crowninshield Endicott Chamberlain	51
Mathilde Townsend	69
Misses Hunter, The	54
Mosquito Nets	70
Mountain Stream	87
Mrs. Gardner in White	92
Mrs. George Swinton (Elizabeth Ebsworth)	40
Mrs. Hugh Hammersley	32
Muddy Alligators	88
Nonchaloir (Repose)	79
Olive Grove, The	72
On His Holidays	46
Palmettos	89
Portrait of Isabella Stewart Gardner	28
Portrait of Lisa Colt Curtis	42
Portrait of Millicent, Duchess of Sutherland	61
Portrait of Mrs. A. Lawrence Rotch	56
Portrait of Mrs. Leopold Hirsch	52
Portrait of Rodin	23
Princess Demidoff	38
Ramón Subercassaux	16
Simplon Pass Reading	80
Sir Philip Sasson	94
Sketchers, The	83
Study of Architecture, Florence	76
Thou Shalt Not Steal	90
Trout Stream in the Tyrol	86
Venetian Interior	59
Venetian Passageway	66
Violet Sleeping	67
Wyndham Sisters, The	45